Twelve ways of Looking at a Painting

An Homage to Jean Hélion and *"Le Grand Luxembourg"*

This book accompanies the exhibition of the same title at the Lovejoy Library, Southern Illinois University Edwardsville, Installed October 17, 2013.

Editors: Glen Cebulash, Megan Williamson

Premiere edition (1st edition), January 2014
©2014 Midwest Paint Group,
Director: Timothy King
t_king_design@hotmail.com
ALL RIGHTS RESERVED
Printed by Blurb in the U.S.A

Cover and page 11 – Jean Hélion, *Le Grand Luxembourg*, 1956
page 12 – Jean Hélion, *Original Sketch for Le Grand Luxembourg*, 1954

page 13 – Jean Hélion, *Study in October: Trees*, 1954
page 13 – Jean Hélion, *Study of Trees, Statue & Bench in Winter*, 1954

Reproduce with the permission of the Lovejoy Library, Southern
Illinois University Edwardsville,

Page 7 – Portrait au miroir de Jean Hélion dans son atelier devant "Grand Luxembourg" (huile sur toile), France ; Ile-de-France ; Paris ; Paris 06
Photographe Colomb, Denise, 1957,
© Ministère de la Culture / Médiathèque du Patrimoine, Dist. RMN-Grand Palais / Art Resource, NY

Midwest Paint Group
midwest-paint-group.org

Twelve ways of Looking at a Painting

An Homage to Jean Hélion and *"Le Grand Luxembourg"*

Lovejoy Library
Southern Illinois University Edwardsville
October 17, 2013

An exhibition produced by
Southern Illinois University Edwardsville
and the Midwest Paint Group

Jean Hélion

with

Bob Brock

Glen Cebulash

Deborah Chlebek

Tina Engels

Philip Hale

Timothy King

Lynette Lombard

Jeremy Long

Amy Maclennan

Michael Neary

Ron Weaver

Megan Williamson

All in all, after a journey through nature and working only from nature for two years,

I'm returning to my own domain, the world of concepts.

– Jean Hélion
1904 – 1987

Mirror reflection of Jean
Hélion with *Le Grand Luxembourg*.

Photograph by Denise Colomb

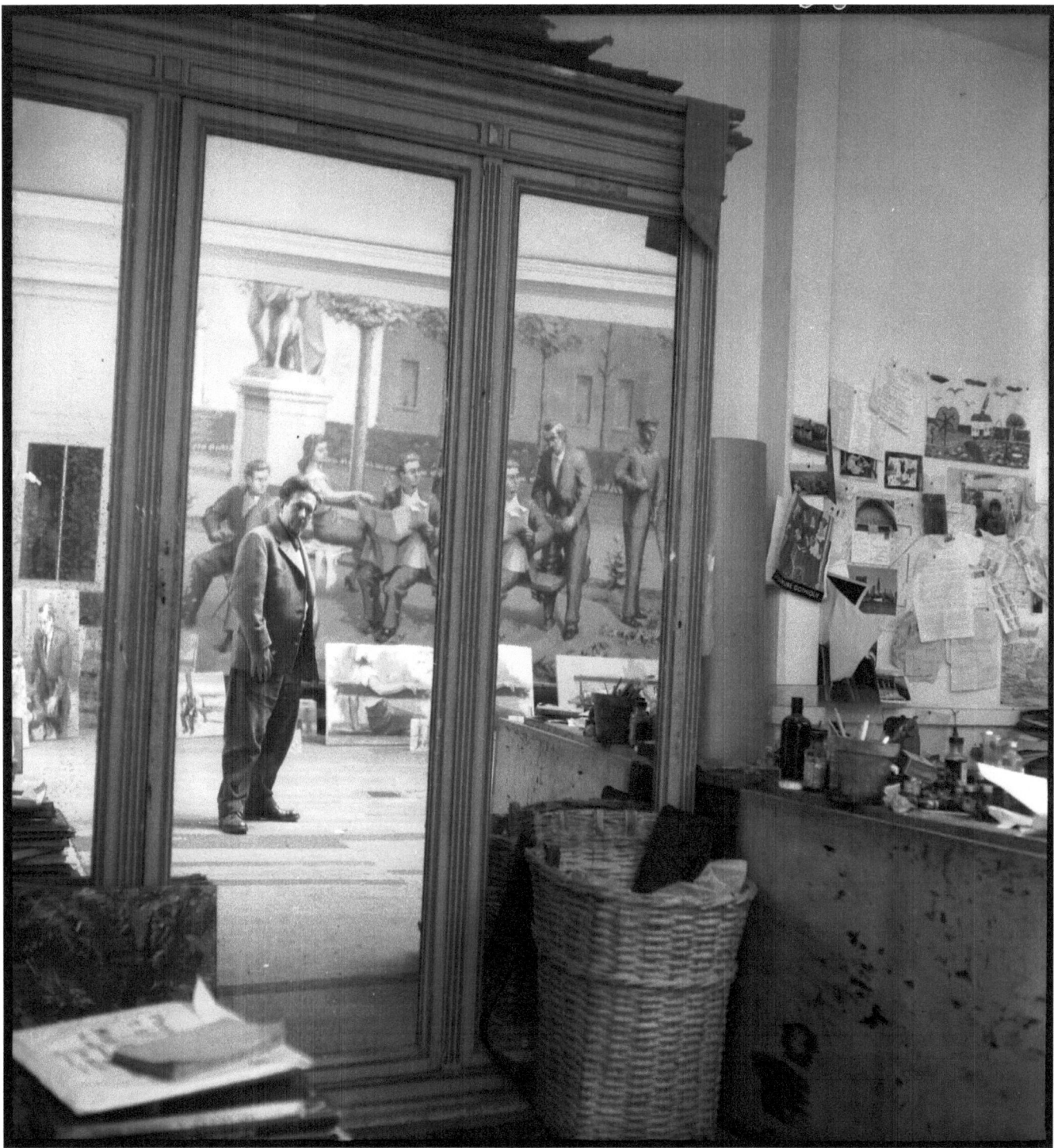

Le Grand Luxembourg

In February 2013, The University Museum at Southern Illinois University Edwardsville was approached by Glen Cebulash, Chair of the Department of Art and Art History at Wright State University, on behalf of the Midwest Paint Group. Individually and collectively, the twelve members of that group have been influenced by the work of the French artist, Jean Hélion.

Mr. Cebulash expressed the group's interest in creating a series of artworks in response to our Hélion painting. Through our conversations we came up with the idea of hosting a visual symposium in which the various artists present their work and establish what we hope is a visual dialogue among the artists that can be shared by a broader audience.

SIUE is fortunate to have in our collection an important painting by Hélion entitled *Le Grand Luxembourg*. Joseph Cantor of Carmel, Indiana donated this painting to the University in 1965 through the efforts of Katherine Kuh who was responsible for assembling the original art collection of SIUE. This painting came to SIUE rolled as one would a large rug. Due to the size of the piece, it had to be stretched in situ. *Le Grand Luxembourg* is an important work because it marked the height of Hélion's post-WWII departure from Universal Abstract painting and subsequent movement towards representational art.

Eric B. Barnett
Director
The University Museum
Southern Illinois University Edwardsville

Jean Hélion

Le Grand Luxembourg

1954–57

Oil on canvas

118 x 156 inches

(10 x 13 feet)

Southern Illinois University Edwardsville

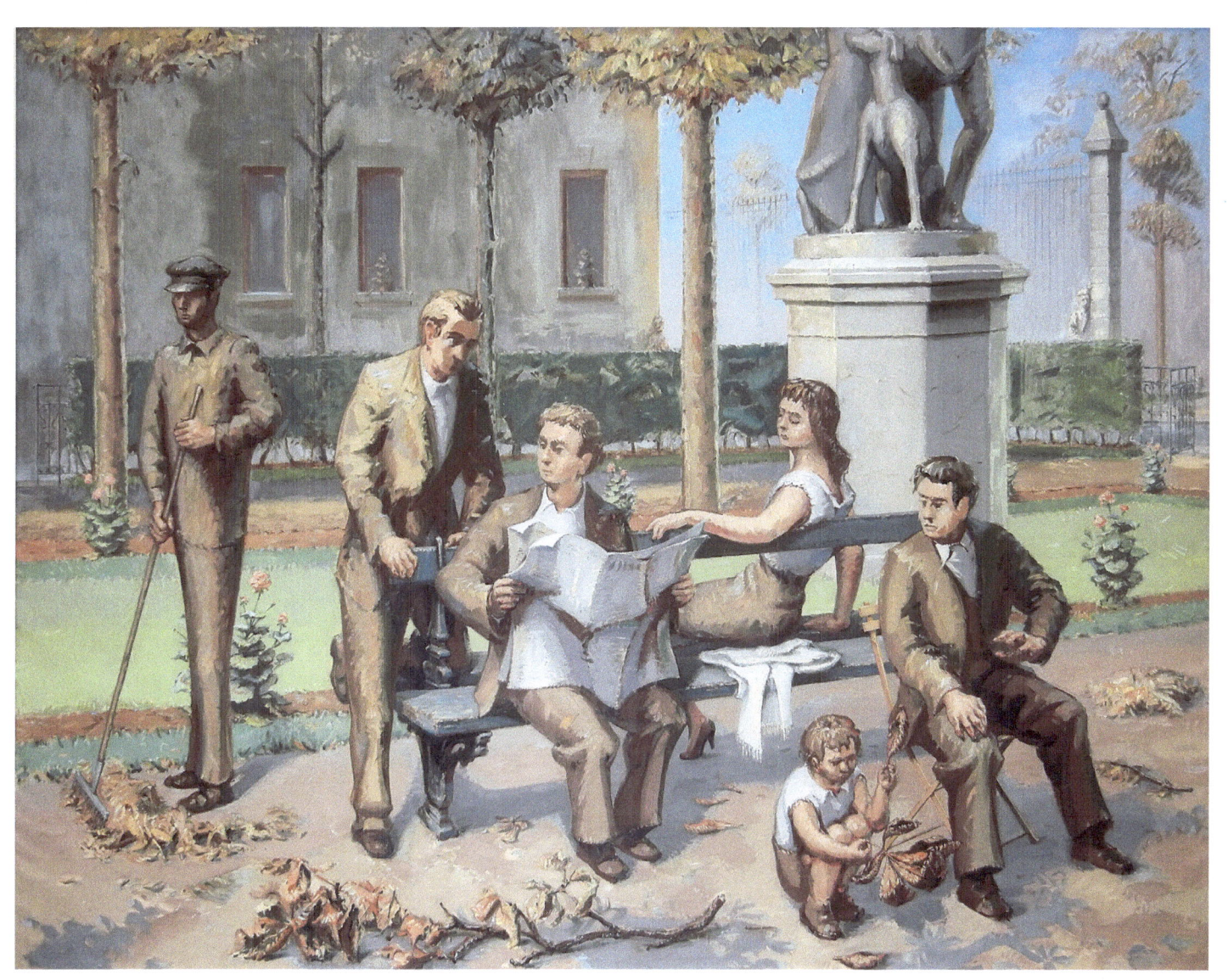

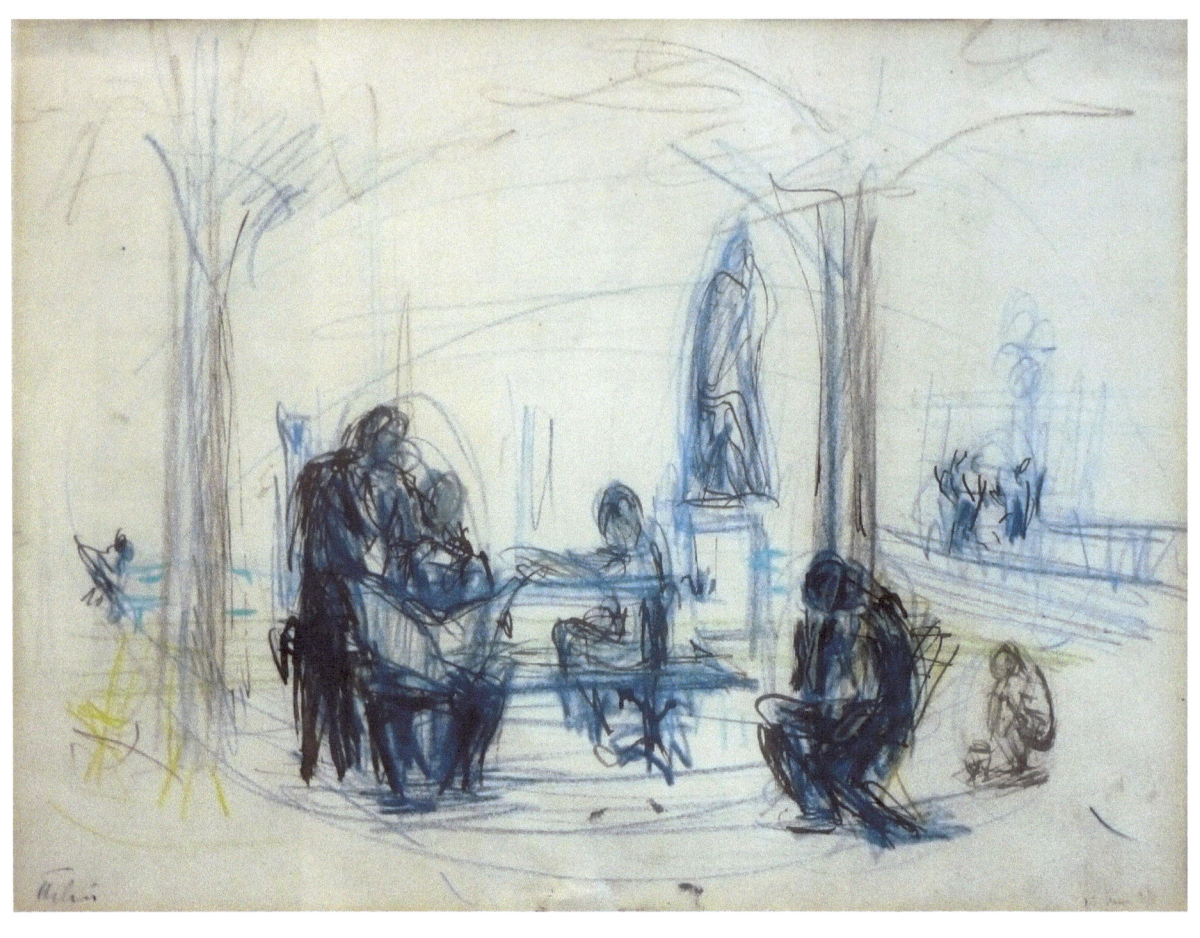

Jean Hélion
Original Sketch for Le Grand Luxembourg
1954
Drawing - Watercolor
Southern Illinois University Edwardsville

Jean Hélion
Study in October: Trees
1954
Drawing - Pen and Crayon
Southern Illinois University
Edwardsville

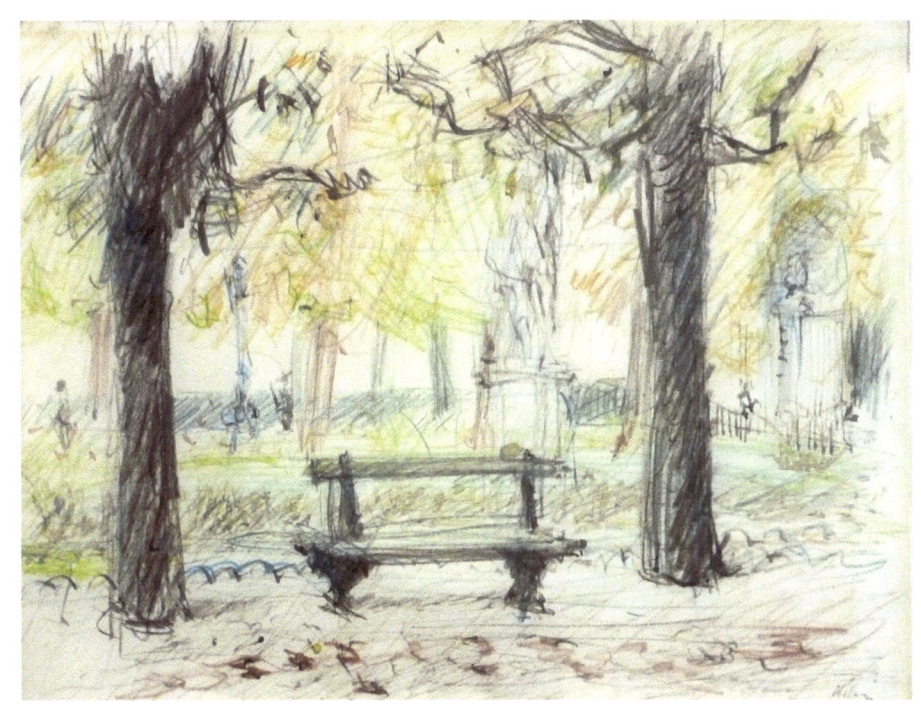

Jean Hélion
Study of Trees, Statue & Bench in Winter
1954
Drawing - Crayon
Southern Illinois University
Edwardsville

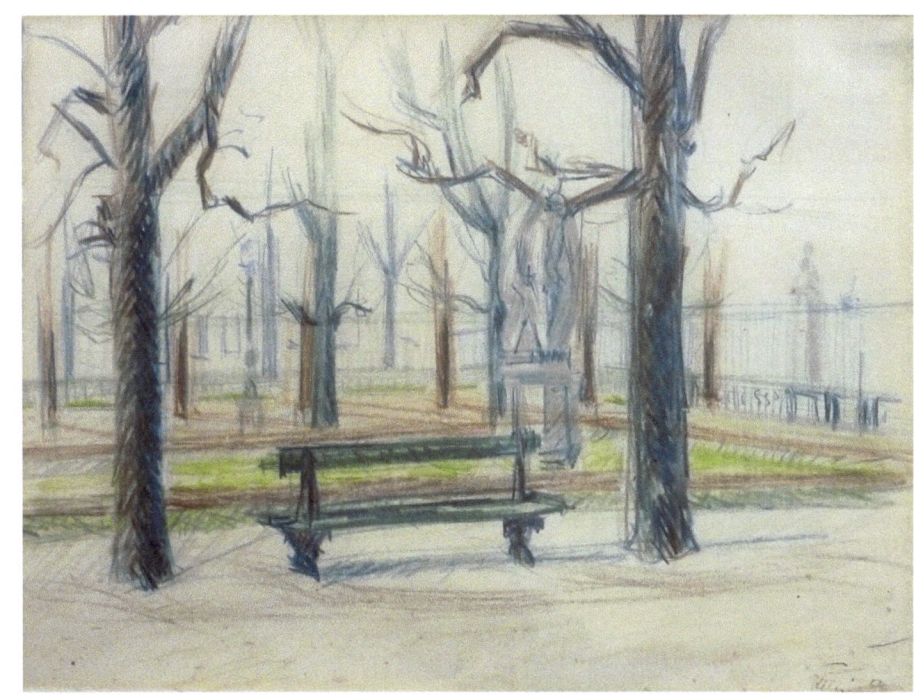

Bob Brock

After Hélion

2013

Graphite and oil on panel

24 x 36 inches

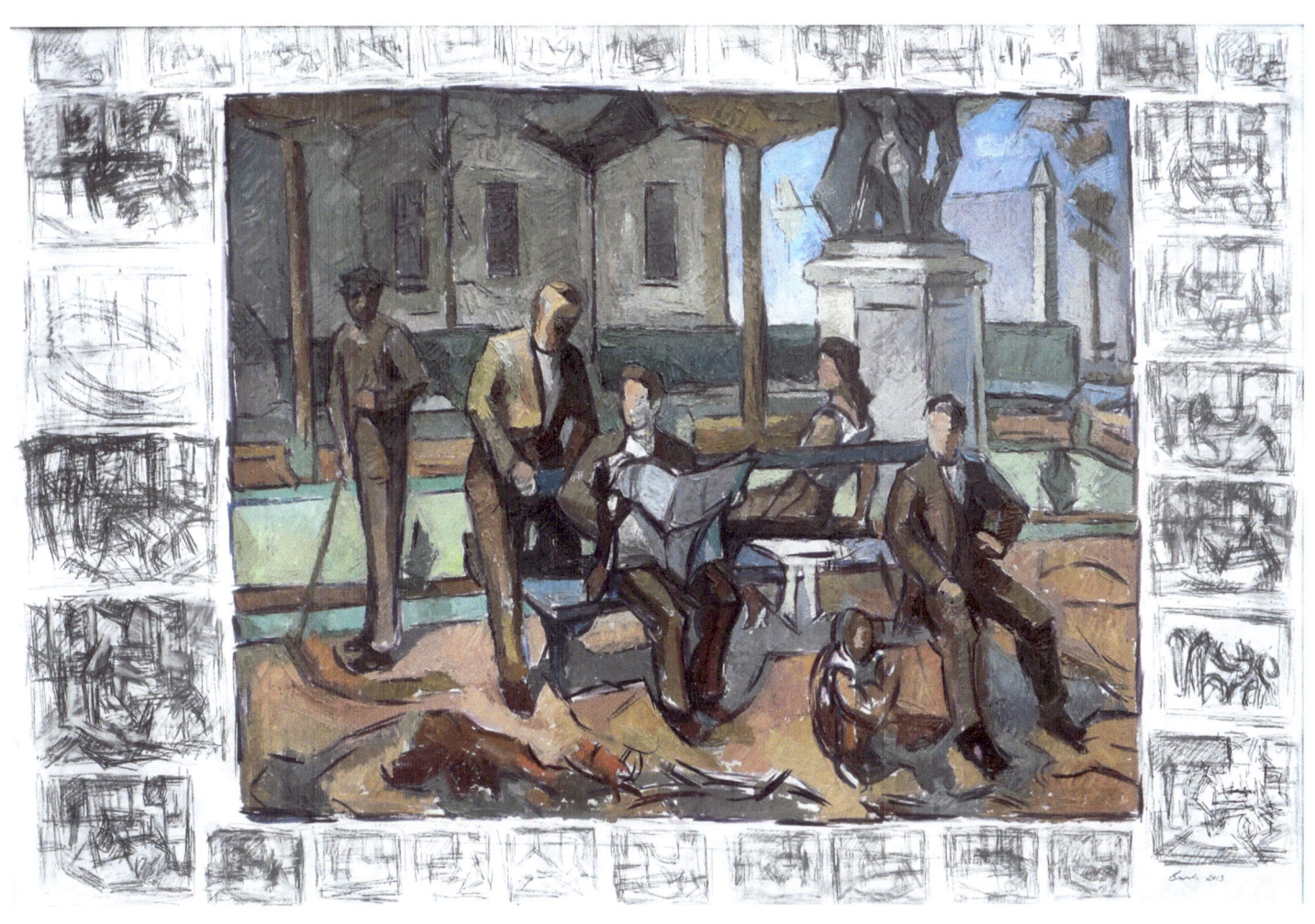

Glen Cebulash
Untitled (after Hélion)
2013
Cut paper
16.25 x 20.5 inches

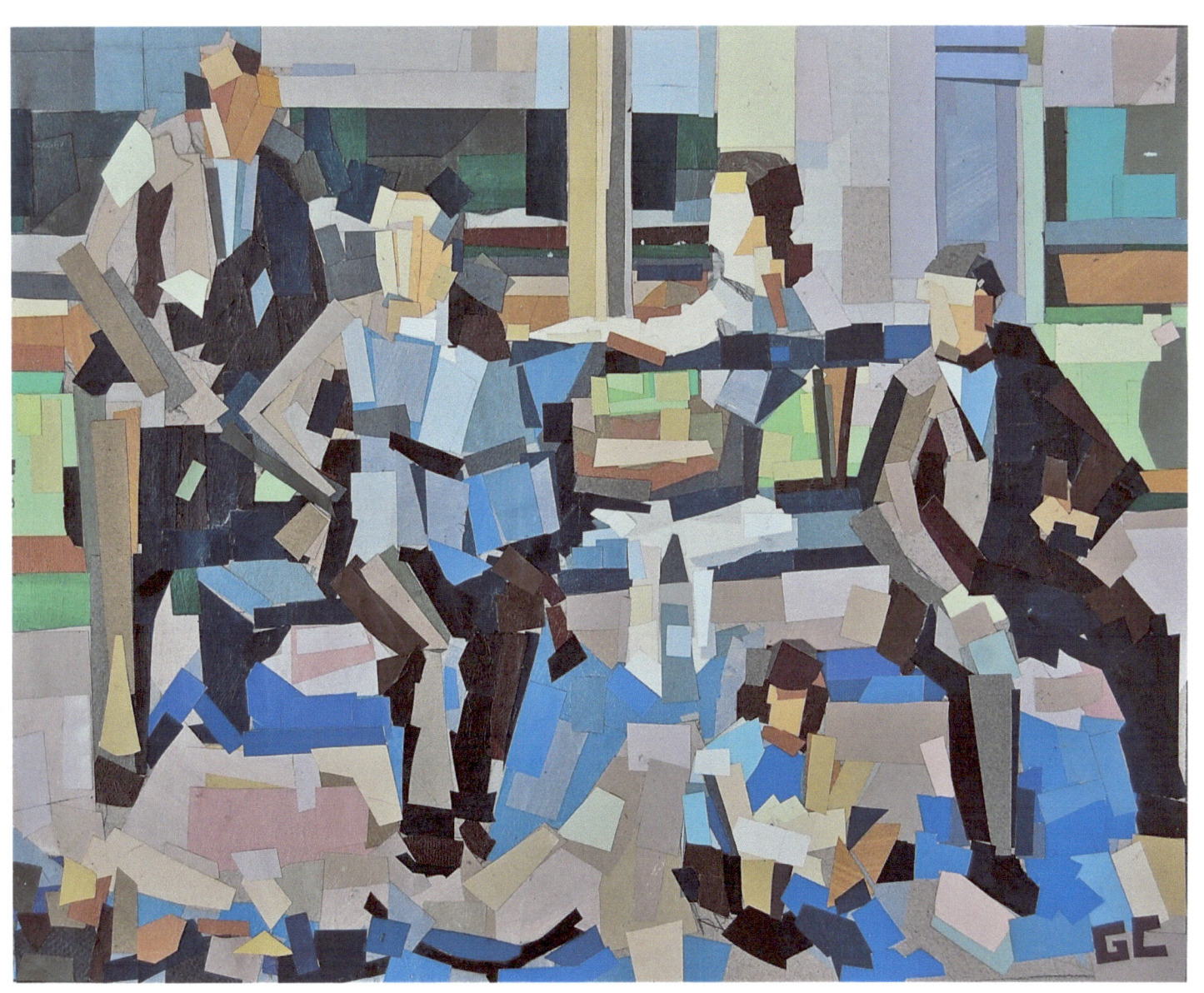

Deborah Chlebek

Helion Study

2013

Oil on paper

20 x 26 inches

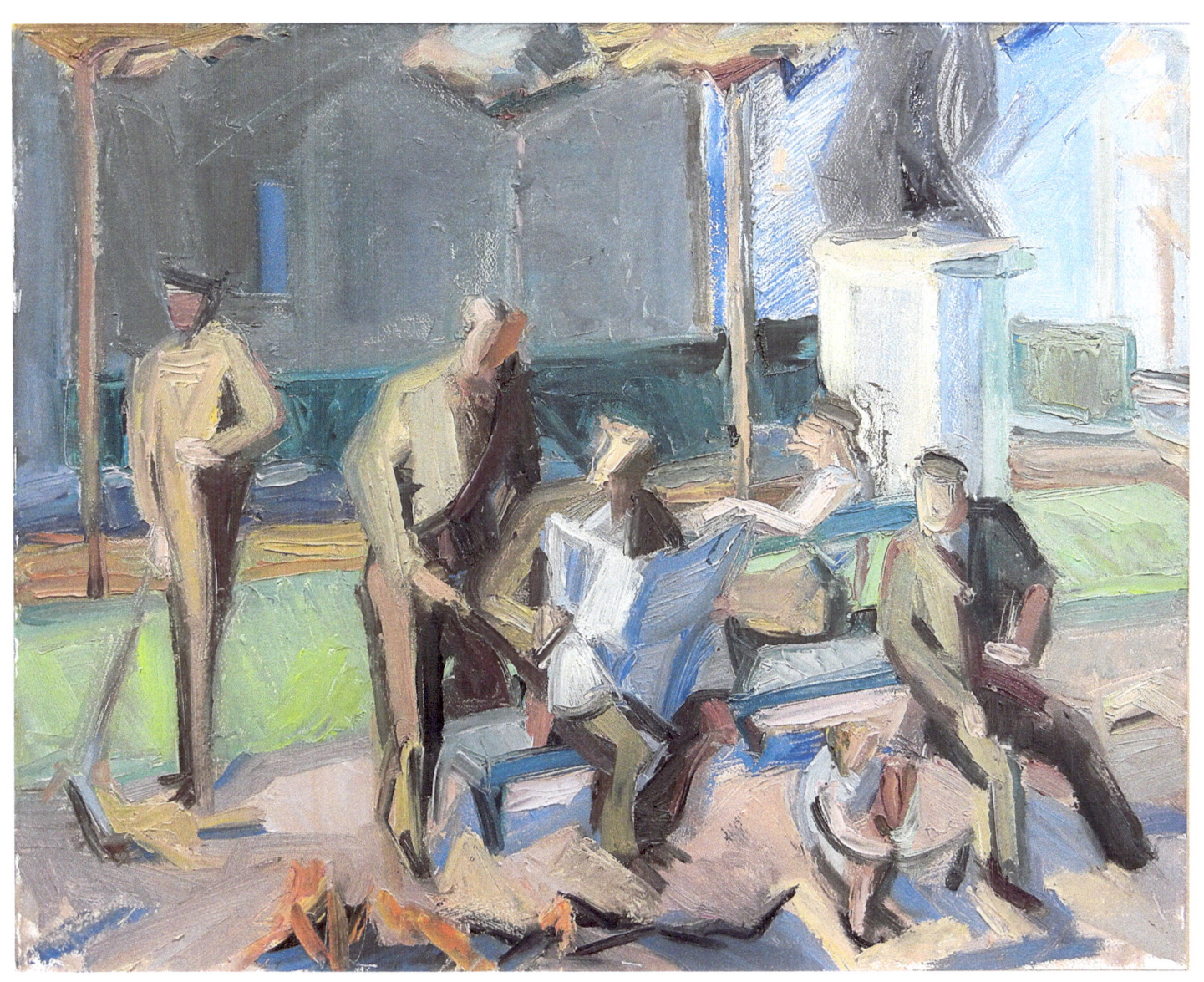

Tina Engels
Understudy
2013
Oil on canvas
16 x 18 inches

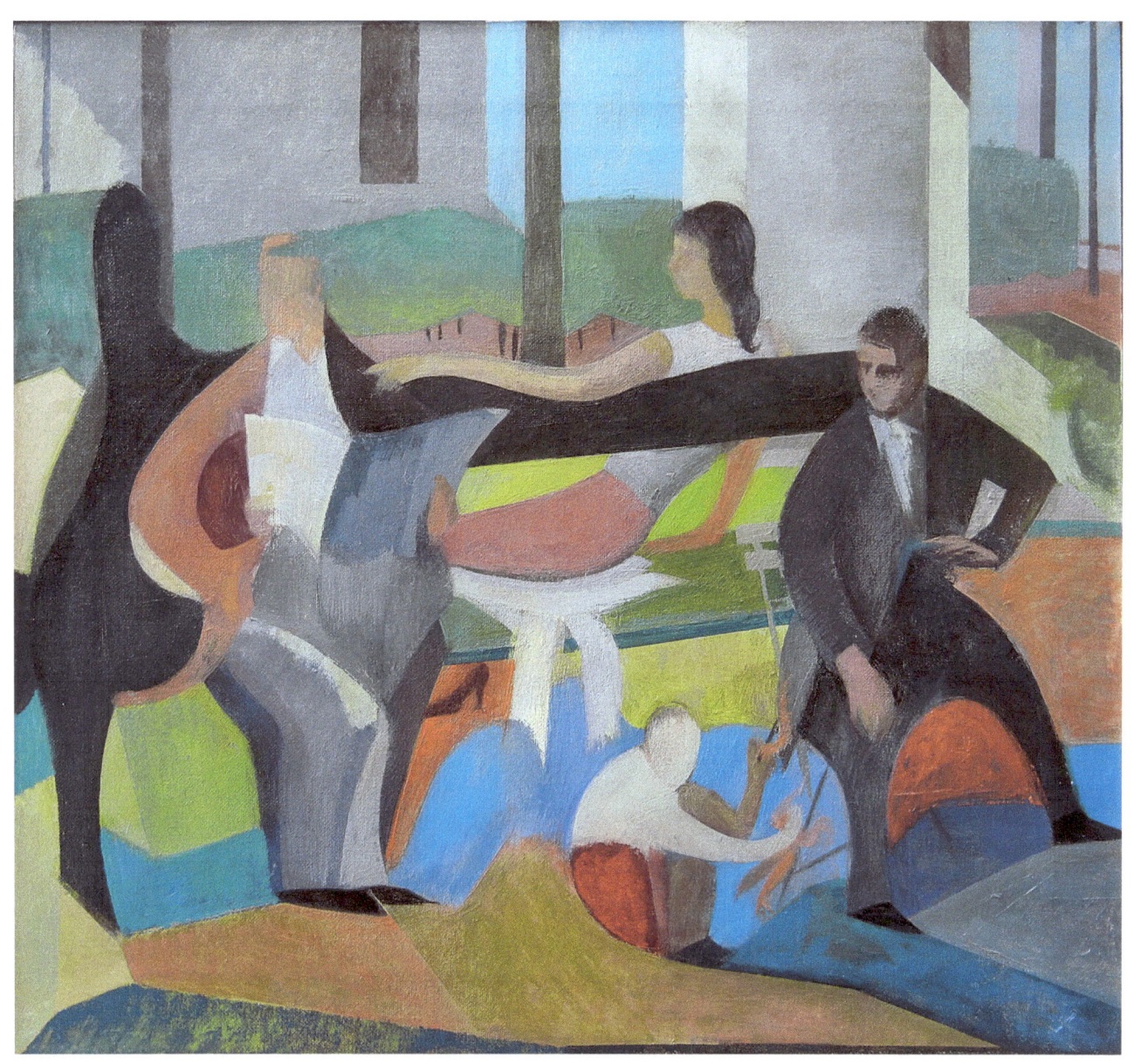

Philip Hale
Hélion Study
2013
Oil on paper mounted on canvas
21 x 28 inches

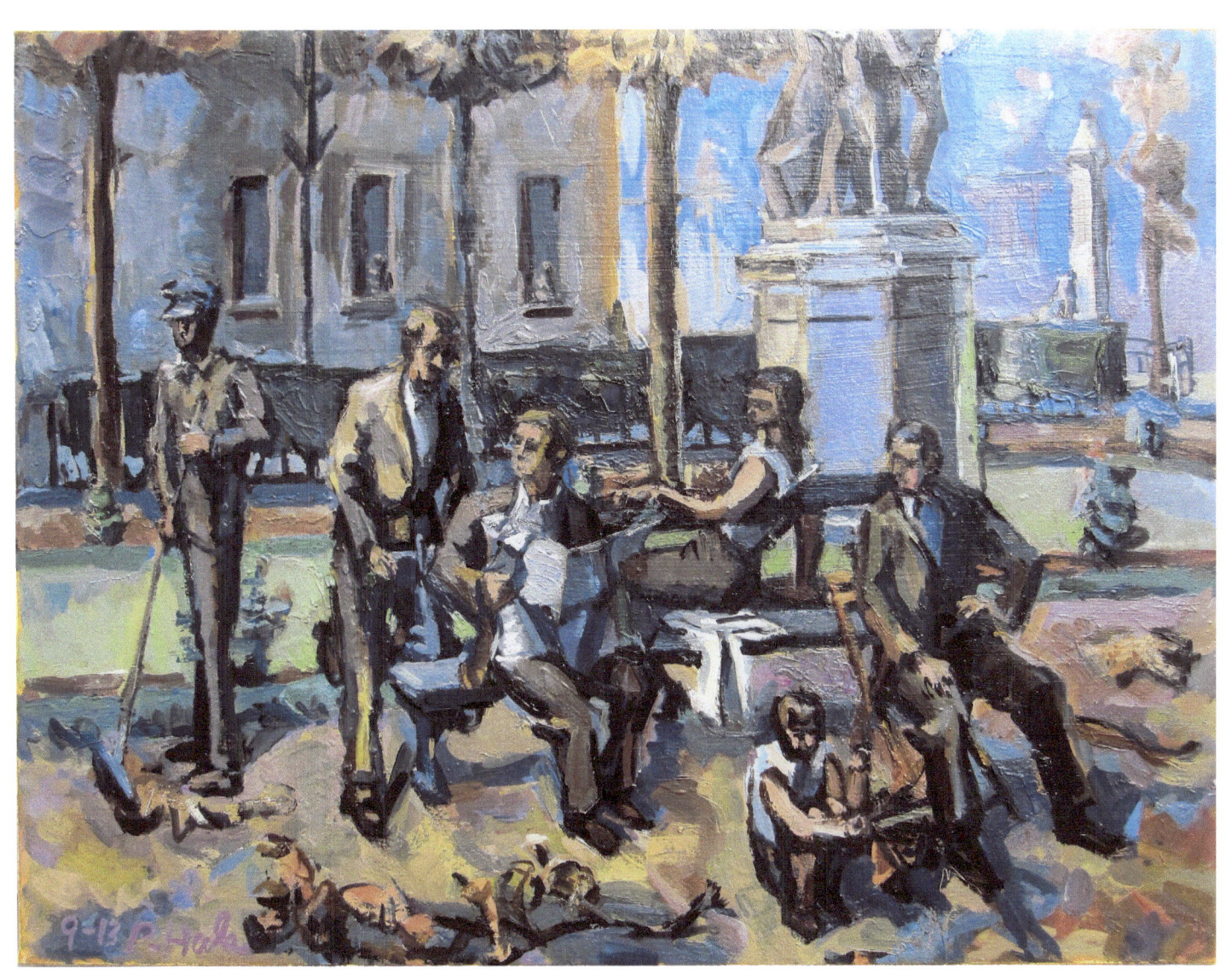

Timothy King
After Hélion's
Le Grand Luxembourg
2013 Pastel on board
28 x 36 inches

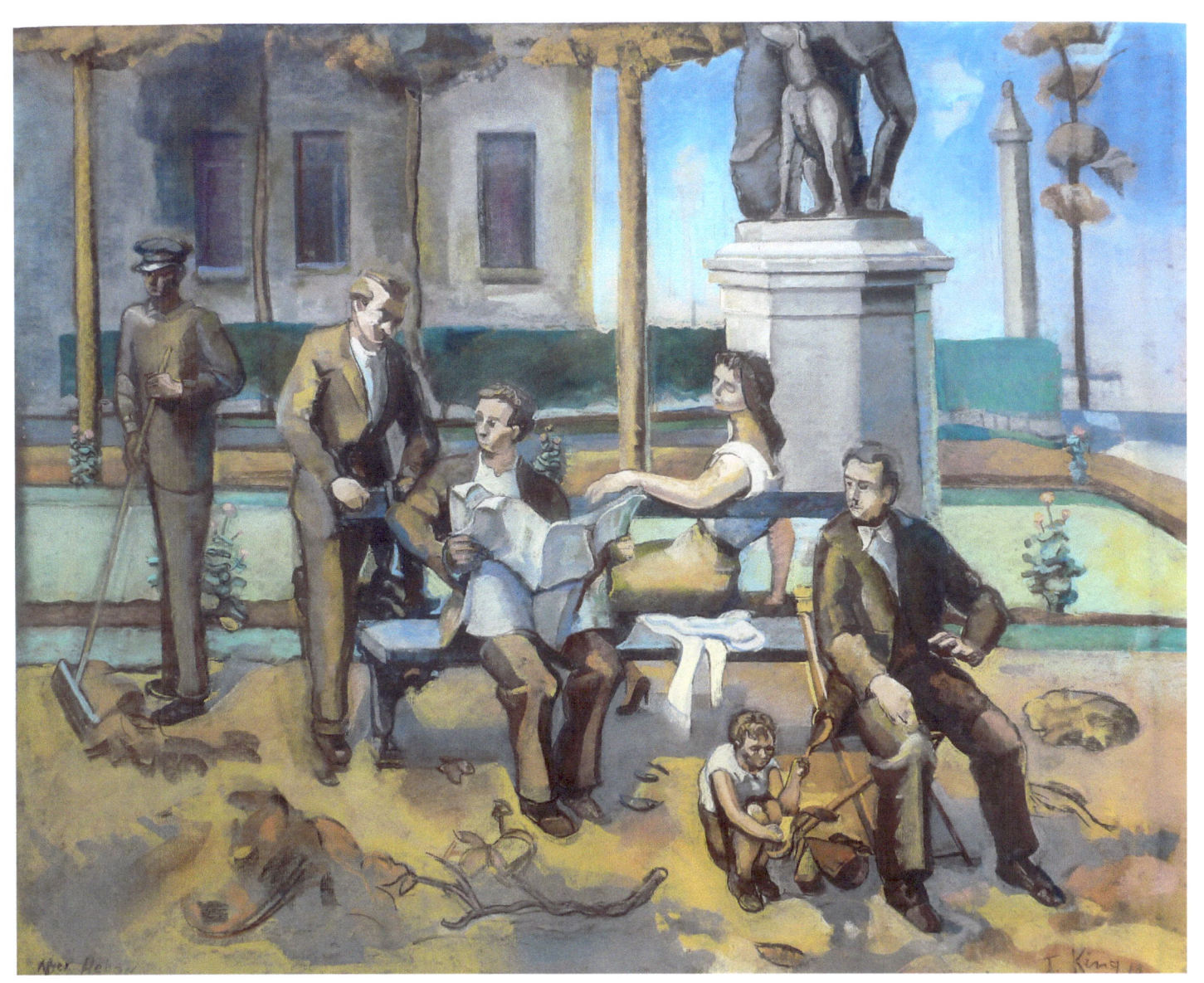

Lynette Lombard

After Hélion

2013

Charcoal on paper

24 x 30 inches

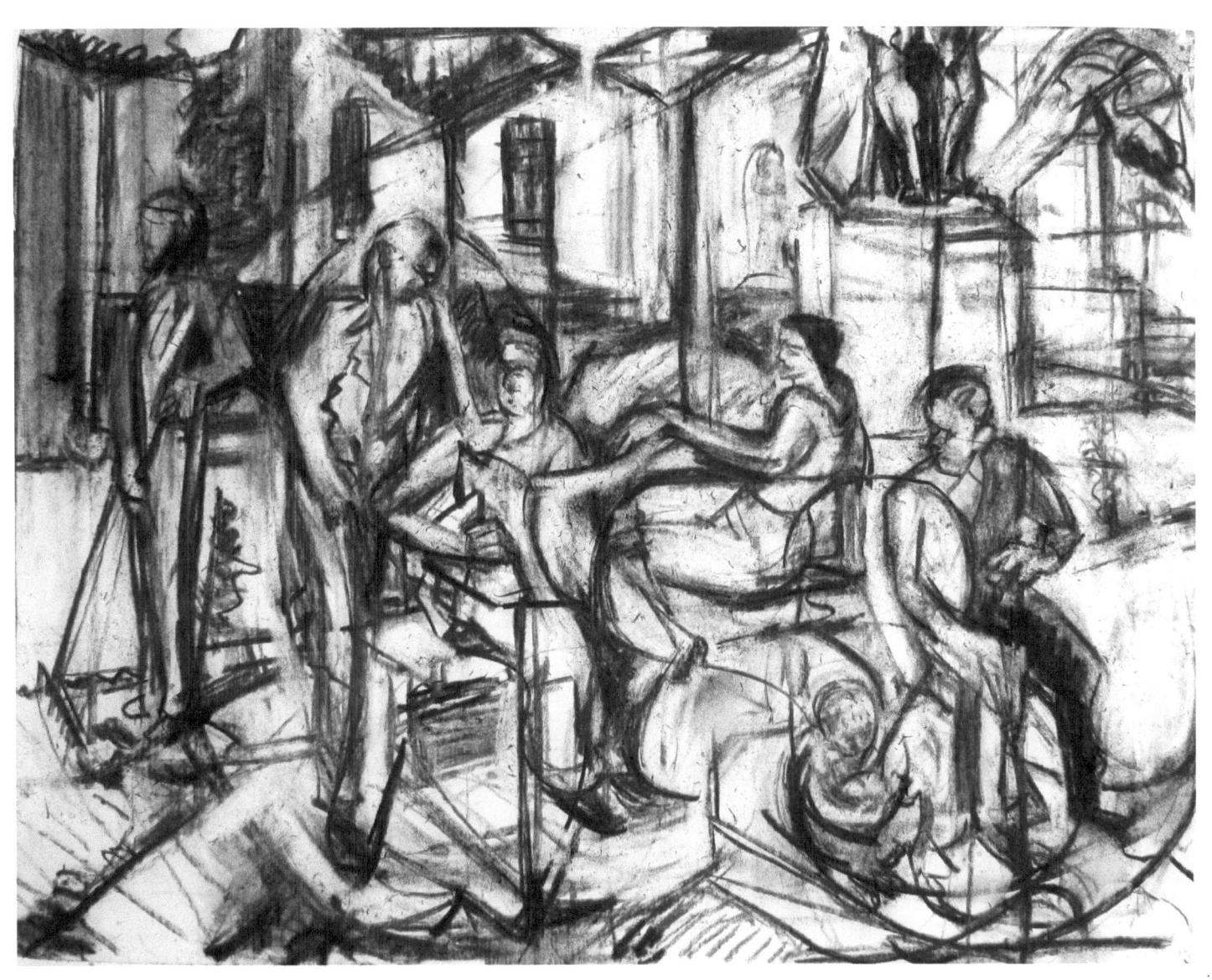

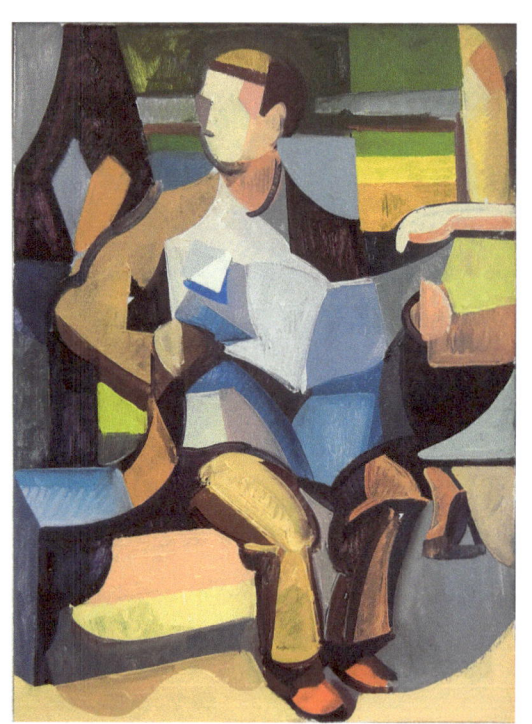

Jeremy Long

Le Grand Lux # 1

2013

Oil on paper

14 x 26 inches

Le Grand Lux # 2

2013

Oil on paper

16 x 12 inches

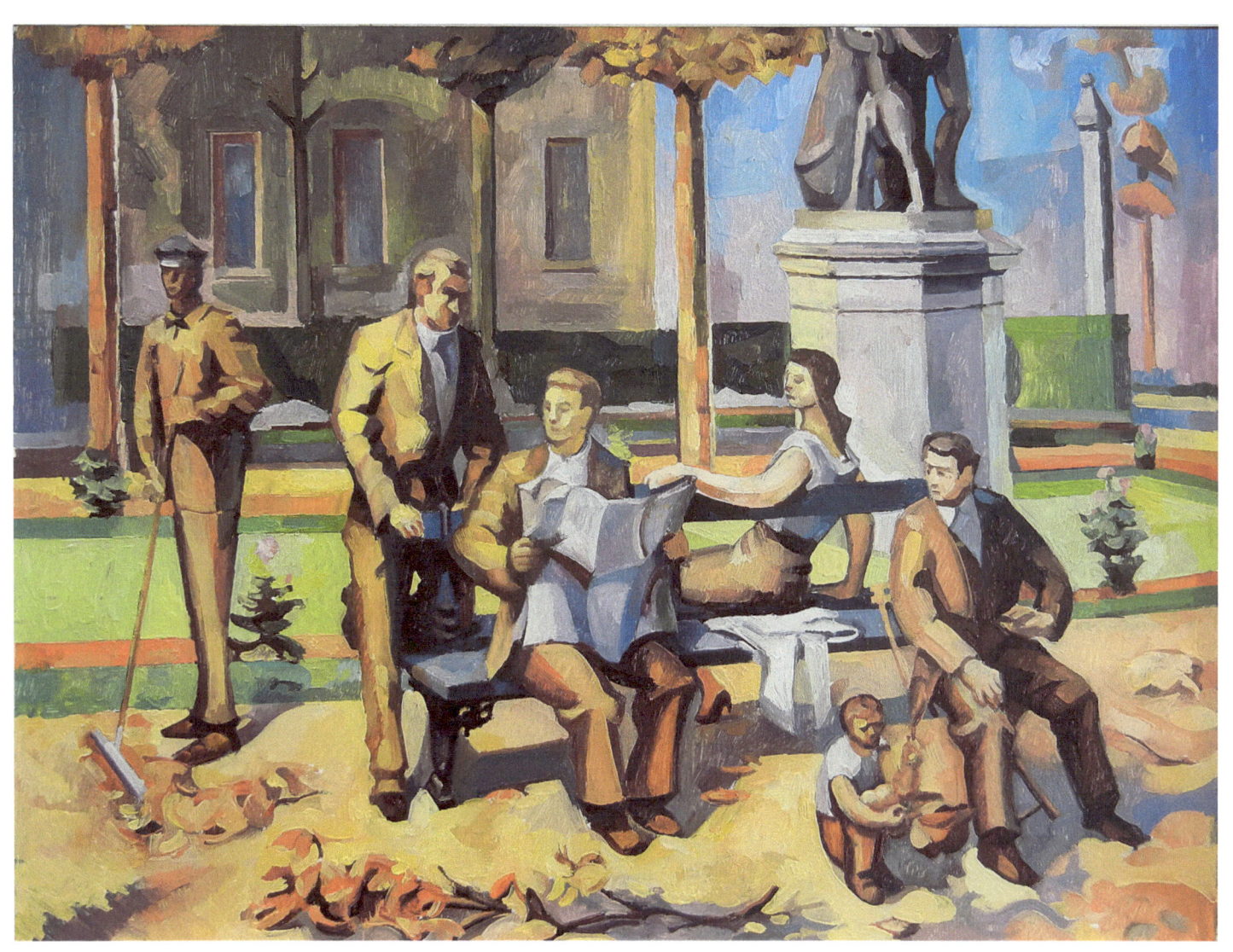

Amy Maclennan
Two Step with Hélion
2013
Acrylic on watercolor paper
18 x 28 inches

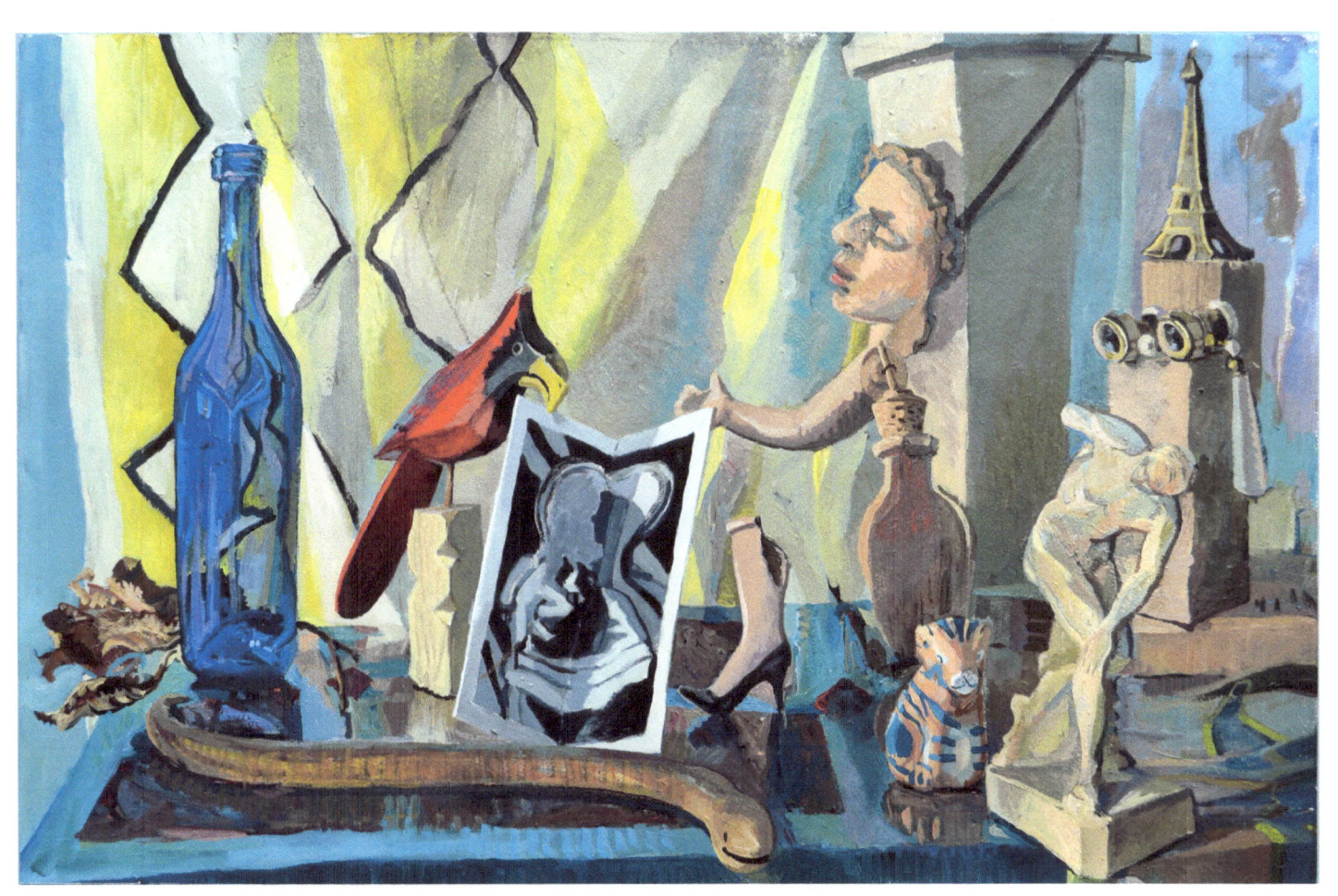

Michael Neary

Hélion Sings the News

2013

Acrylic on BFK

24 x 38 inches

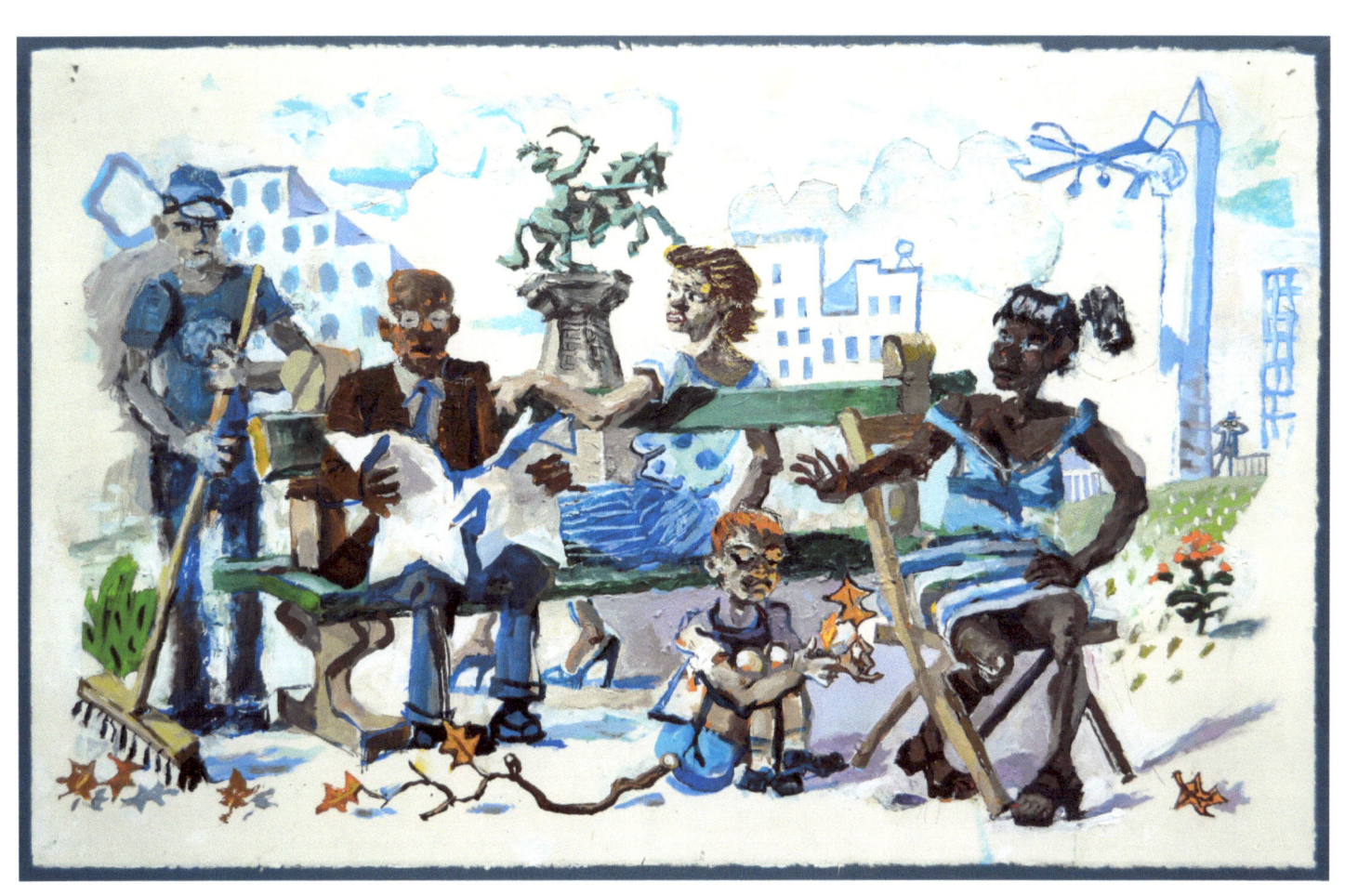

Ron Weaver
Le Grand Luxembourg
Study after Hélion
2013
Acrylic on canvas
24 x 36 inches

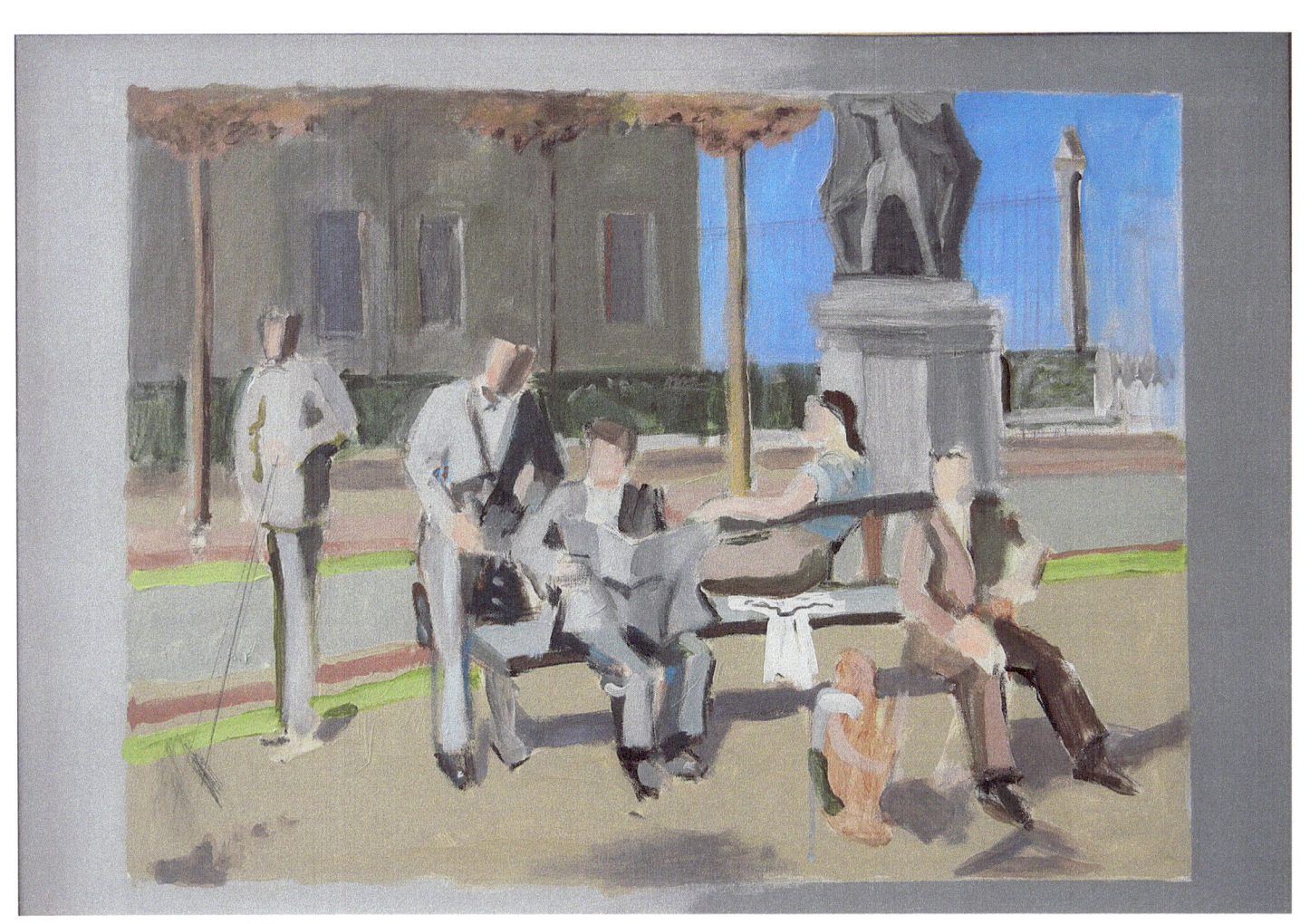

Megan Williamson
After Hélion
2013
Sumi ink on claycoat paper
14 x 18 inches

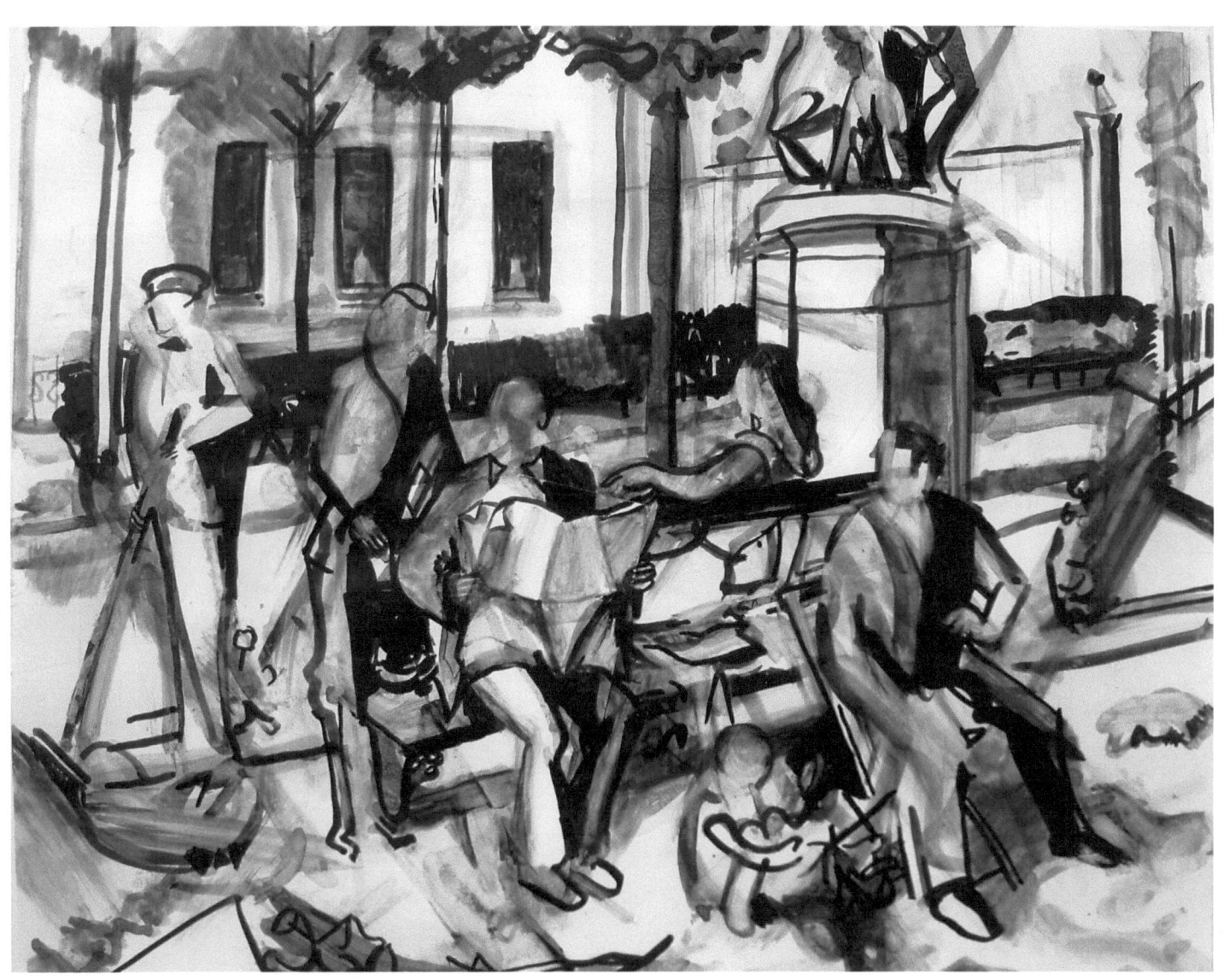

The Gardener and the Painter

Hélion Sept 11, 1966
4 m Michelet
Paris 6

Dear M. Pulley
I hope that you have well received the 3 watercolors of 1954 that Kath. Kuh wrote me to mail you.
One is the very first sketch for this *Grand Luxenbourg*, the 2 others are studies of the park, the bench, the alley in the Luxenbourg Garden where I placed the group.

I kept on drawing the spot way into the winter until it froze so that I suffered too much and asked a gardener if they had any bench in repair, in a stack where I could draw without freezing.
 "No" – but he took me to the superintendent of the garden.
 Ill looking in my working clothes, I told this very distinguished man
 "You do not know me, I am sure, but I need one of your benches to make a large picture. Do you have one to spare?"
 No, we don't, he said and called his head gardener:
"Dig one bench out, and take it to this man's studio."

Letter from Jean Hélion to Charles Pully, University Architect of Southern Illinois University Carbondale, September 11, 1966.

I kept it in my large studio, in
15 avenue de l'Observatoire, for 2 years,
the sculptor Bill Chattaway helped me to
build a base, for it. The painter Charles
Marks took the photographs of that
bench, seen with the pictures, and both of
us posing as the main characters,
that I trust Katherine has forwarded to
you as a diapositive.(photographic slide)
 Perhaps this little story – which is mentioned
in one of the very first issues of the Art
magazine "L' Oeil", (The Eye) will amuse you.

Mr Charles Marks who is now
back to the States for the winter will
order a complete set of these diapositives
and hold them at your disposal.
 I enclose a bill for the drawings.

 Sincerely yours
 Hélion

 I saw a handsome photograph
of the inside of the Lovejoy Library.
My picture is superbly placed. Thank you.

www.ingramcontent.com/pod-product-compliance
Lightning Source LLC
Chambersburg PA
CBHW050358180526
45159CB00005B/2070